COLOR YOUR OWN WALL ART

VINTAGE TEXTILES

Adamsmedia

Avon, Massachusetts

Published by
Adams Media, a division of F+W Media, Inc.
57 Littlefield Street, Avon, MA 02322. U.S.A.
www.adamsmedia.com

Contains material adapted from *Instant Wall Art: Botanical Prints*, copyright © 2015 by F+W Media, Inc., ISBN 10: 1-4405-8566-0, ISBN 13: 978-1-4405-8566-1.

ISBN 10: 1-5072-0035-8
ISBN 13: 978-1-5072-0035-3

Printed in the United States of America.

10 9 8 7 6 5 4 3 2 1

Many of the designations used by manufacturers and sellers to distinguish their products are claimed as trademarks. Where those designations appear in this book and F+W Media, Inc. was aware of a trademark claim, the designations have been printed with initial capital letters.

Cover design by Sylvia McArdle.
Cover and interior illustrations by Claudia Wolf.

This book is available at quantity discounts for bulk purchases.
For information, please call 1-800-289-0963.

COLOR YOUR OWN WALL ART

VINTAGE TEXTILES

25 Color-By-Number Designs

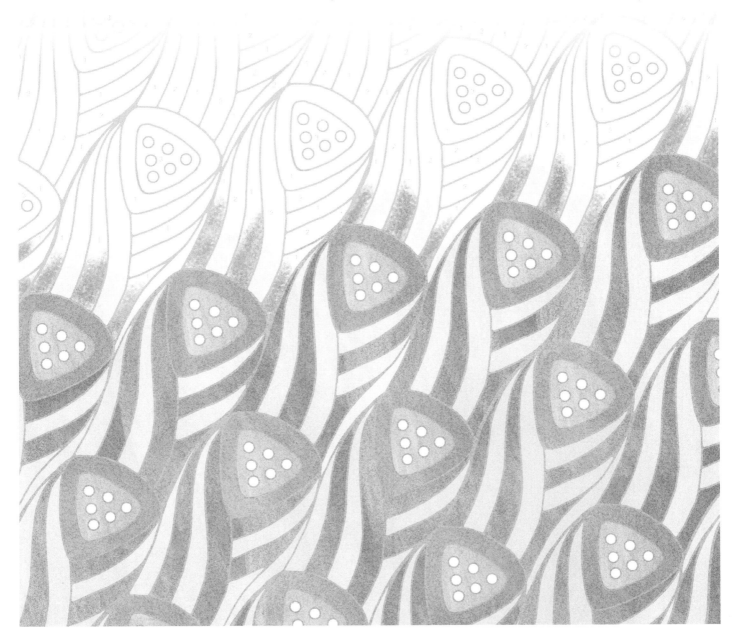

Introduction

Today, vintage textile prints are showing up everywhere you look—from popular design magazines and websites to the walls of your friends' living rooms and kitchens.

And now, instead of having to choose between one or two expensive prints, you can choose from the twenty-five stylish illustrations found within the pages of *Color Your Own Wall Art Vintage Textiles* to create customized artwork for your walls. It's the perfect way to decorate your space with the latest trend and show off your artistic side at the same time.

From chic chinoiserie to romantic bohemian prints to bold geometrics, you're sure to find a print that is perfect for your walls. The best part is, each illustration has been numbered so you can flawlessly add color to bring the patterns to life.

Refer to the color palette on the inside cover of this book to find the color that corresponds with each number. Any spaces that aren't numbered should remain white. You'll also find a fully colored version of each image on the inside of the front or back cover to give you a preview of the lovely picture you will create when you follow the number pattern exactly. But if you'd rather, let your own unique palette guide your hand and personalize your image to match your individual style.

Use the test pages in this book to check your colors and practice your application techniques. Have fun and experiment with the amount of pressure you use as you color.

- Using heavy pressure will produce stronger color saturation for a bold look.

- Light pressure will produce less color saturation for a softer, subtle feel.

- To re-create the faded and worn look of vintage fabric, practice transitioning from heavy pressure to light pressure. Determine where you want to place the faded spots and use the lightest pressure in those areas, gradually increasing pressure as you color away from those spots.

These vintage-textile inspired prints measure 8" x 10" and will fit in a standard mat and frame once removed from the book at the perforated edge. So choose the prints you love, color them, and hang them on your walls to enjoy timeless patterns, and your own creativity, year-round!

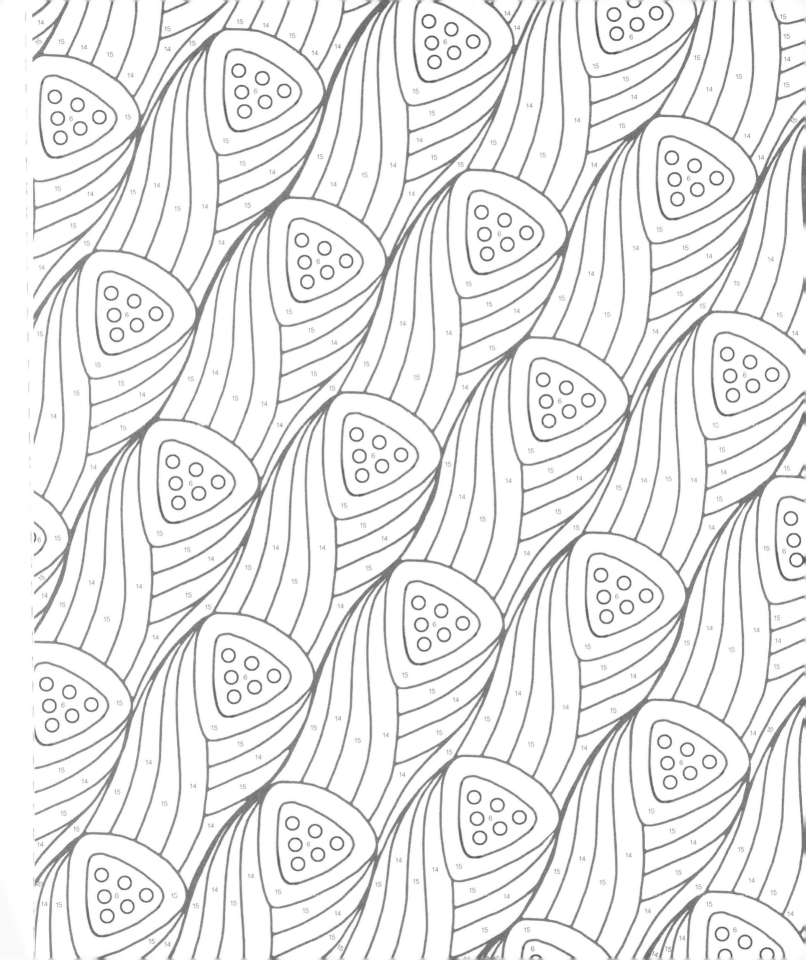

PATTERN 1

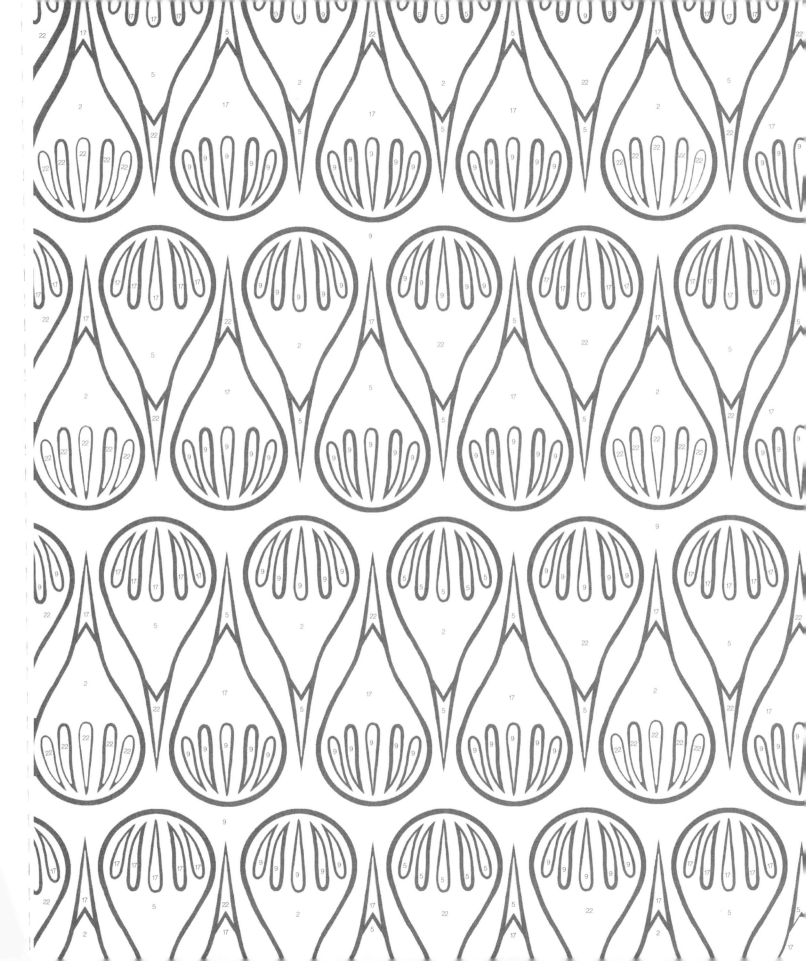

PATTERN 2

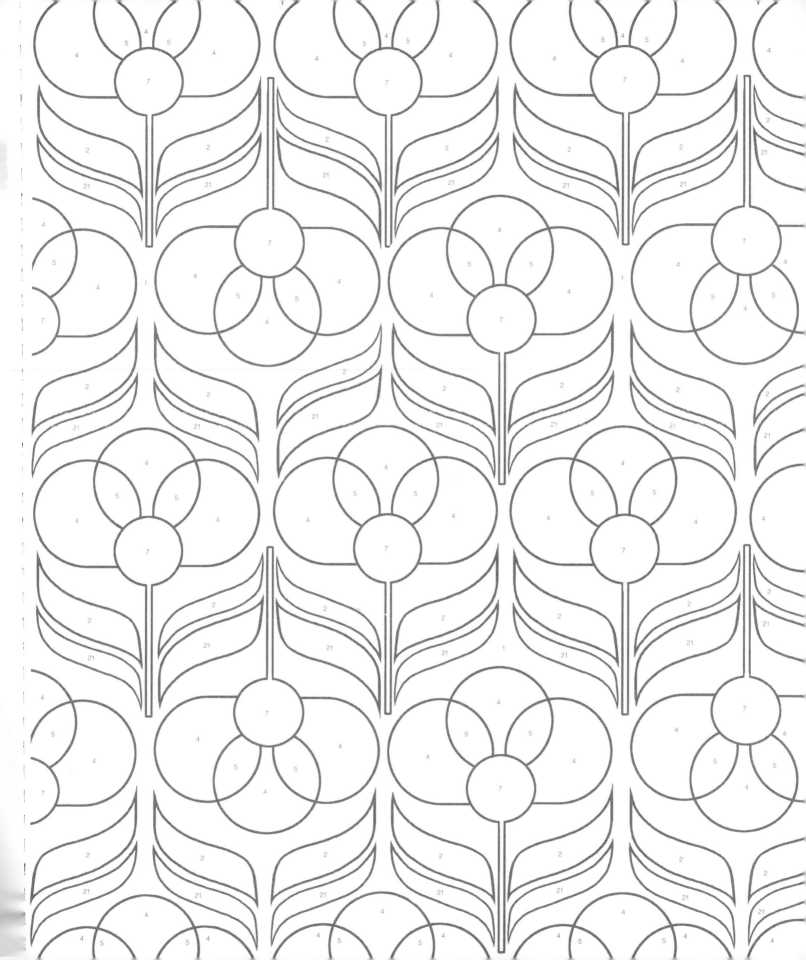

PATTERN 3

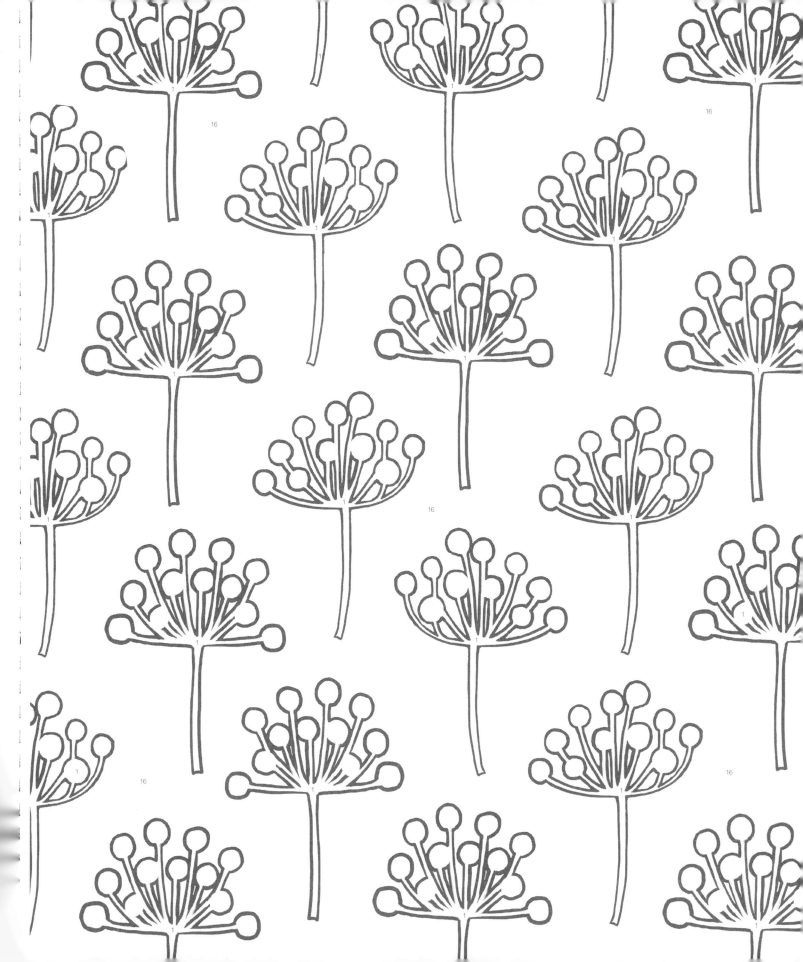

PATTERN 4

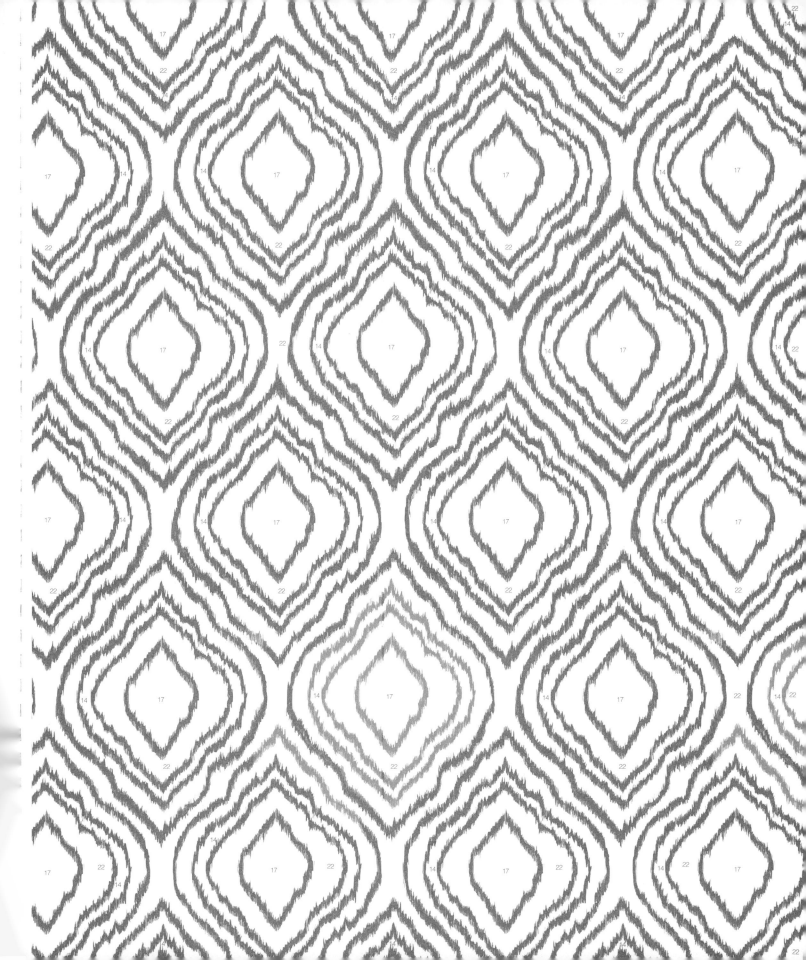

PATTERN 5

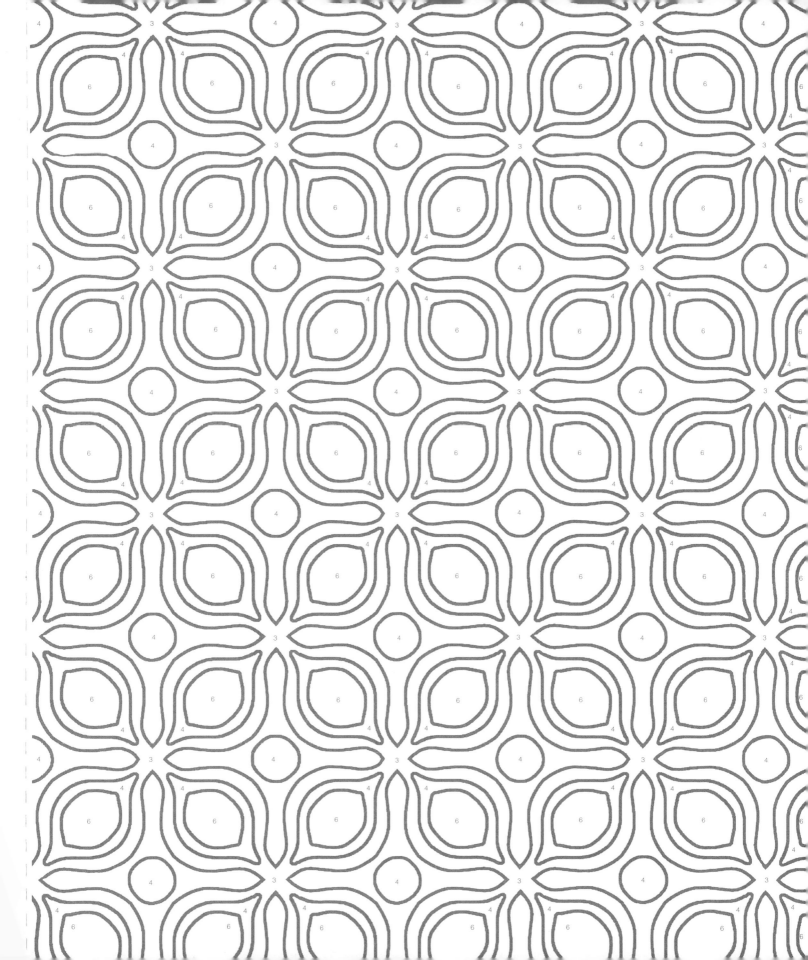

PATTERN 6

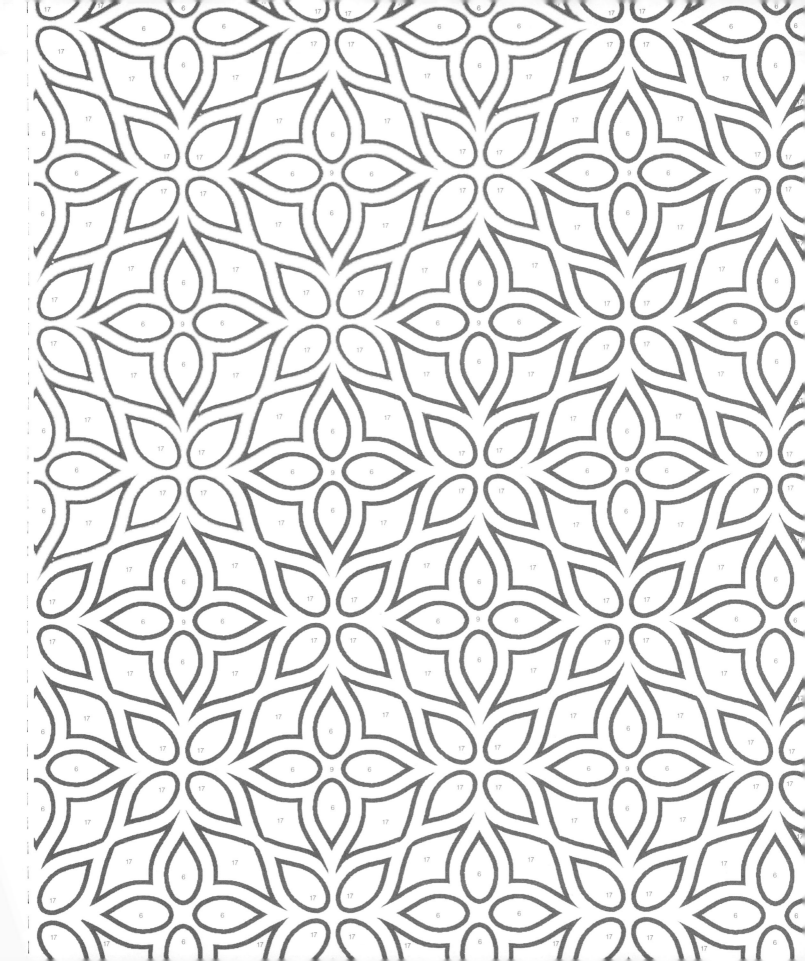

PATTERN 7

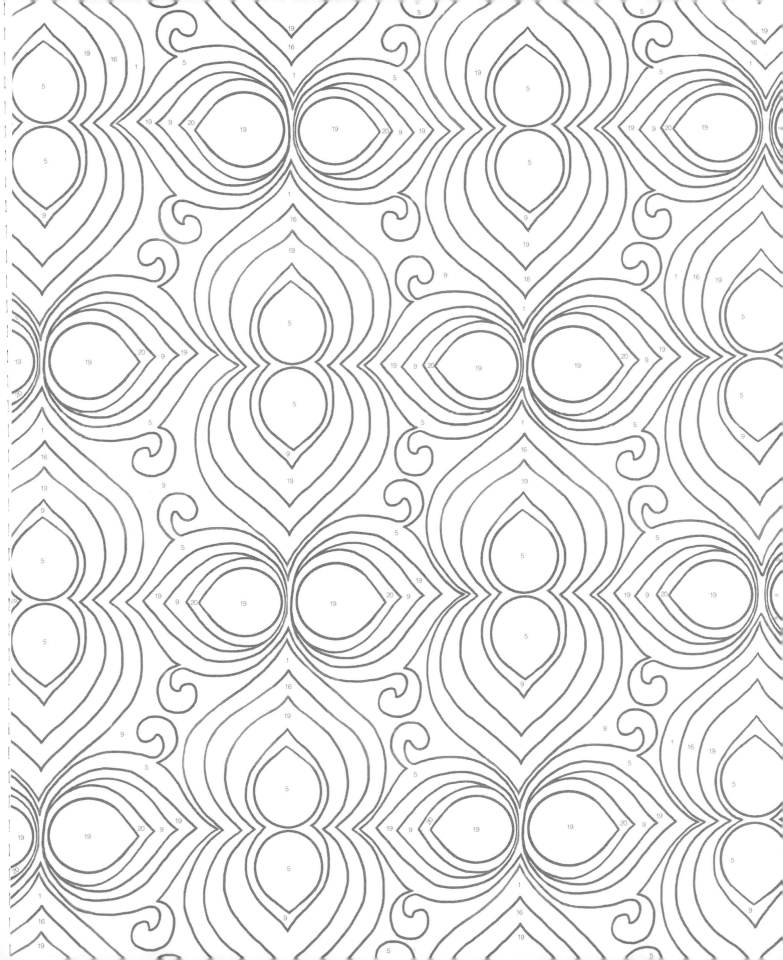

PATTERN 8

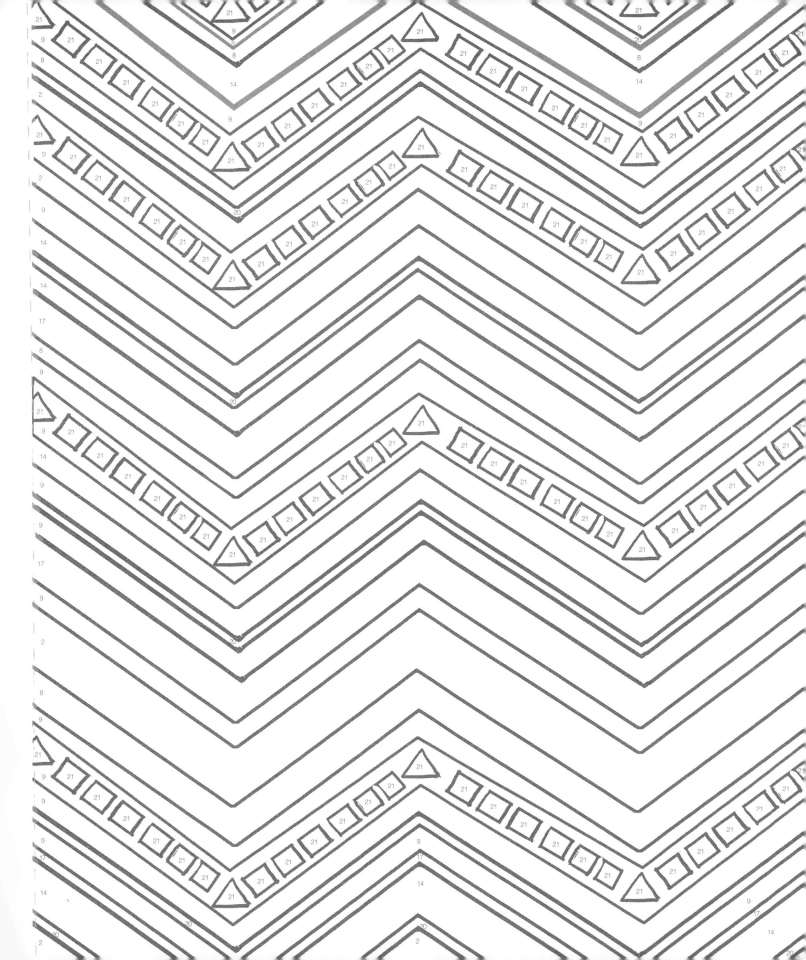

PATTERN 9

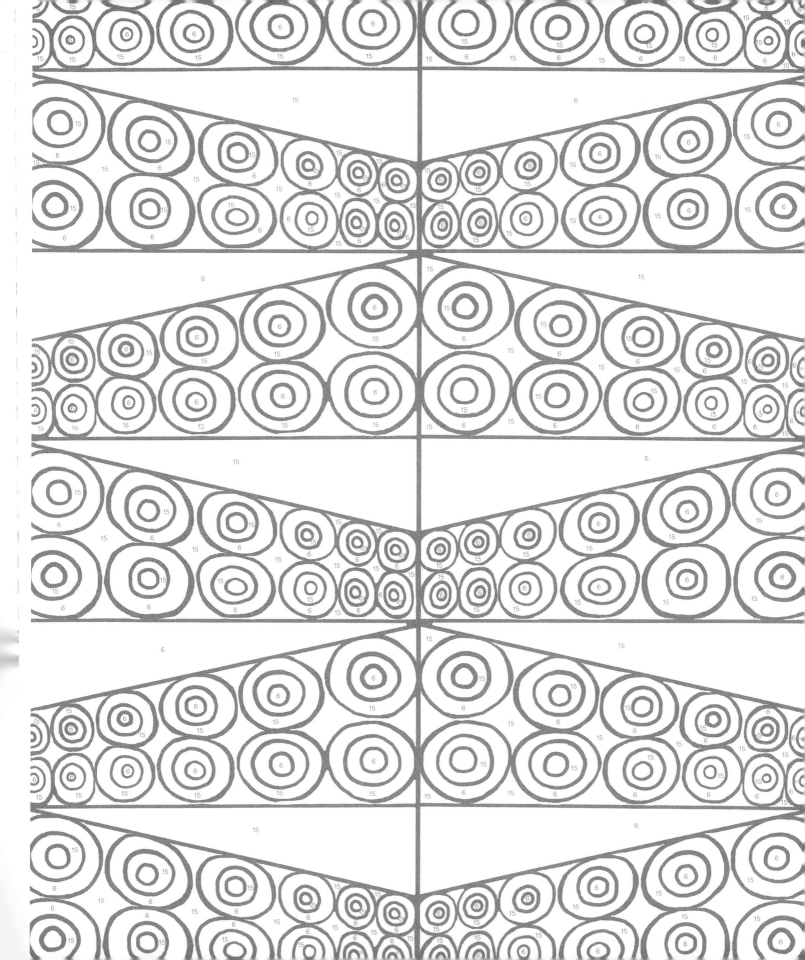

PATTERN 10

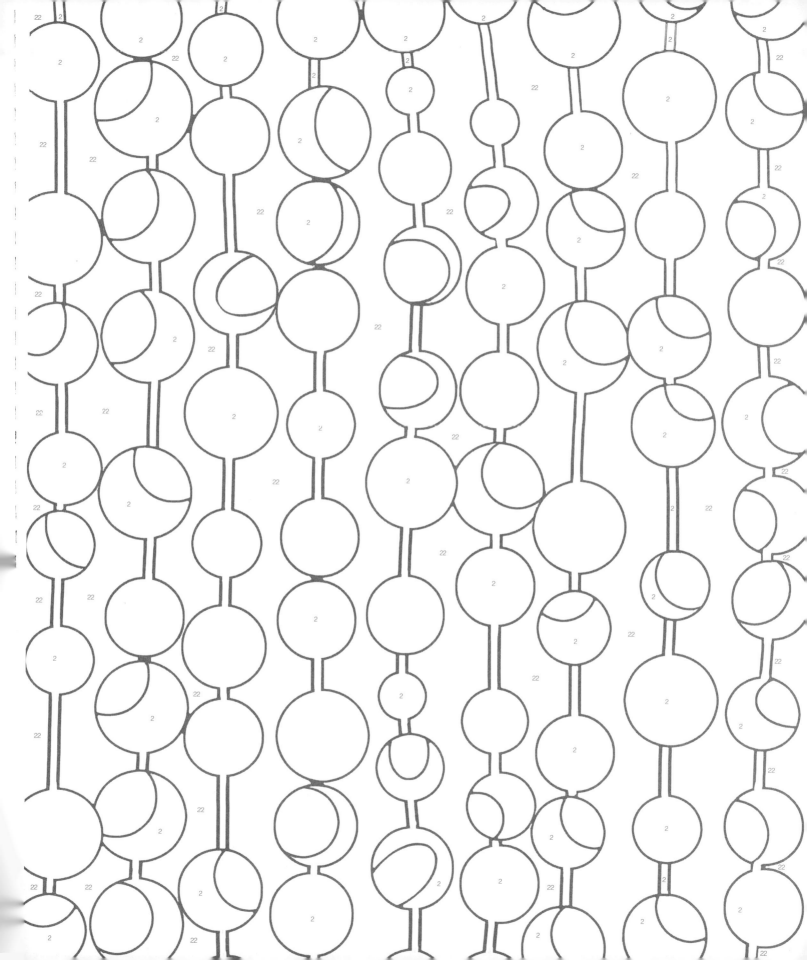

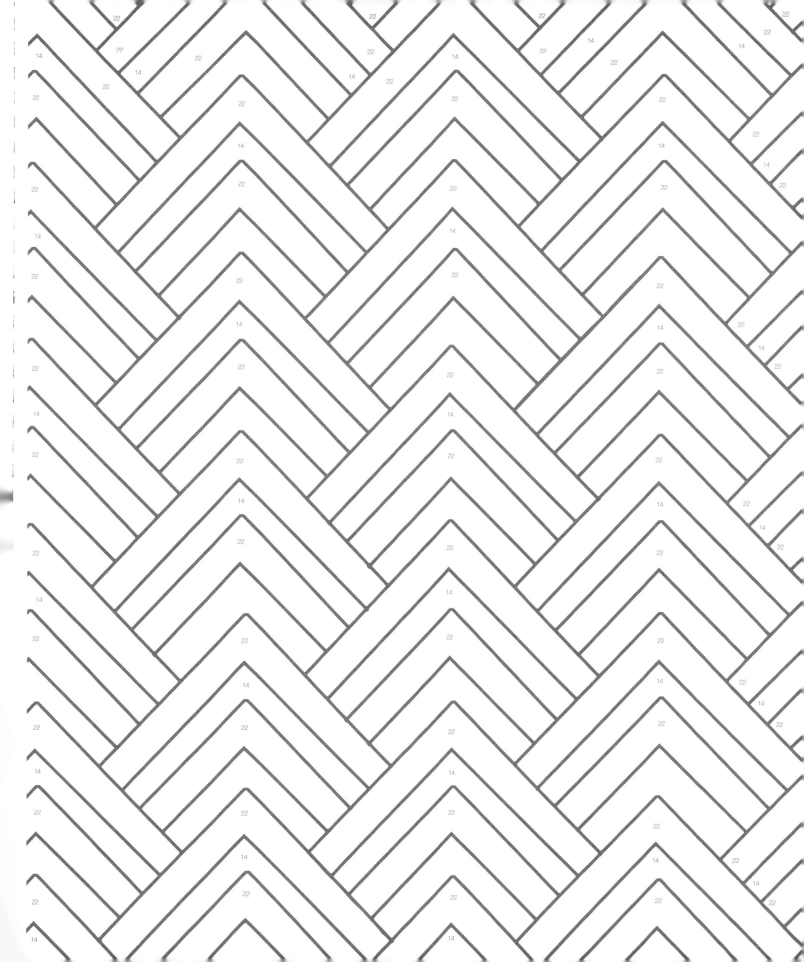

PATTERN 12

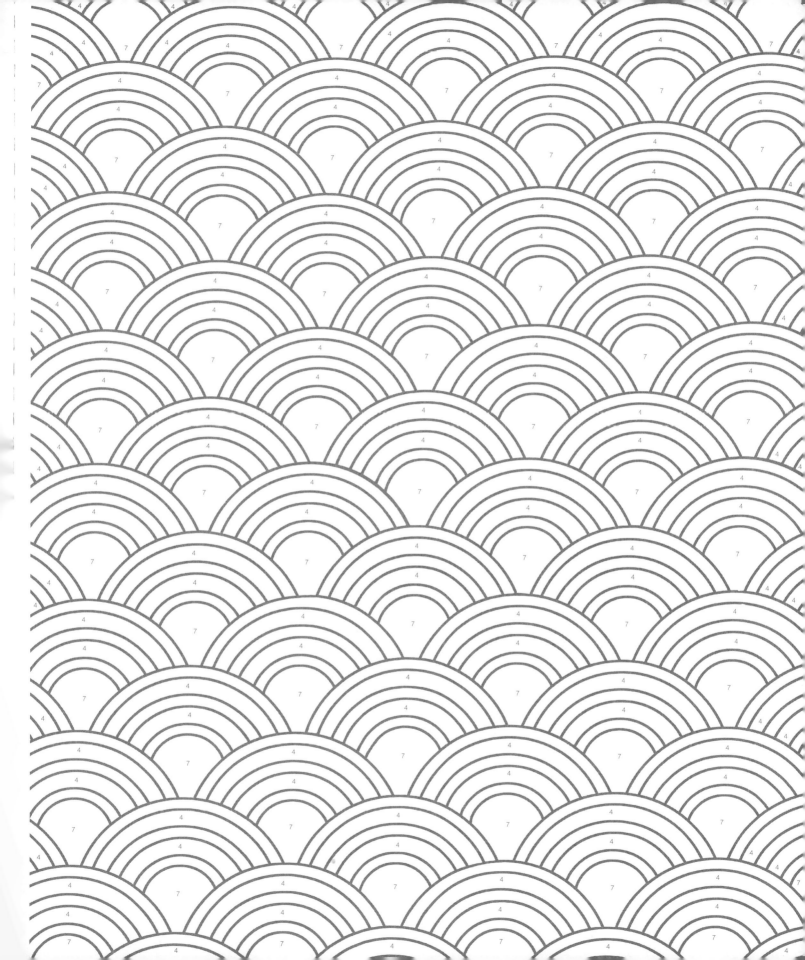

PATTERN 13

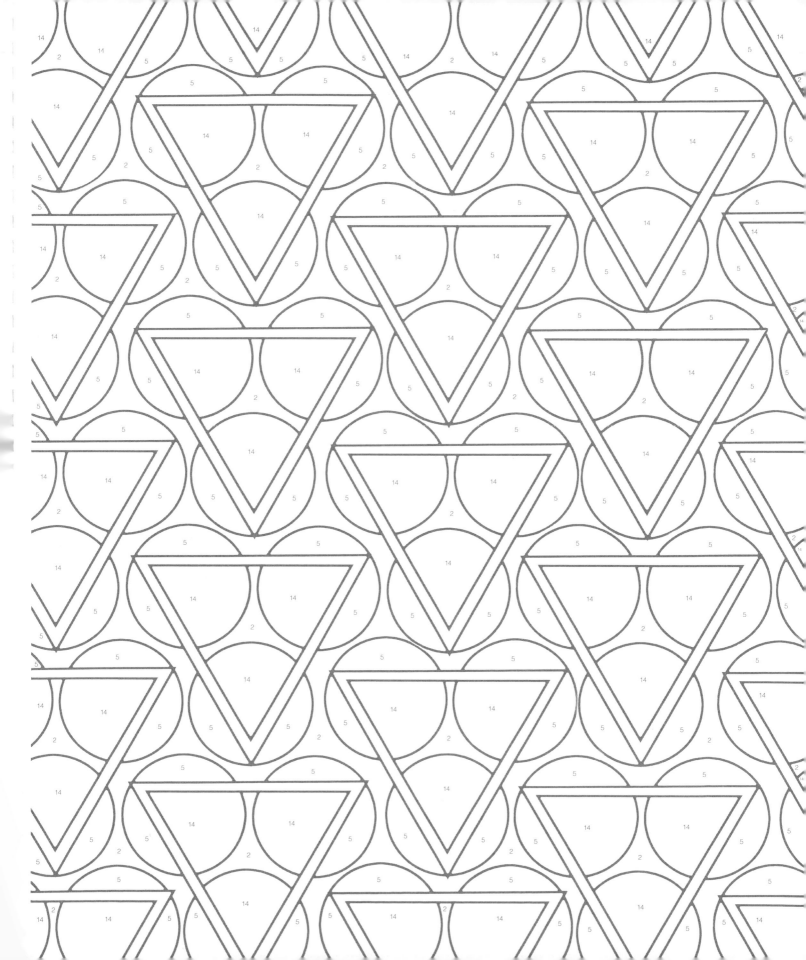

PATTERN 14

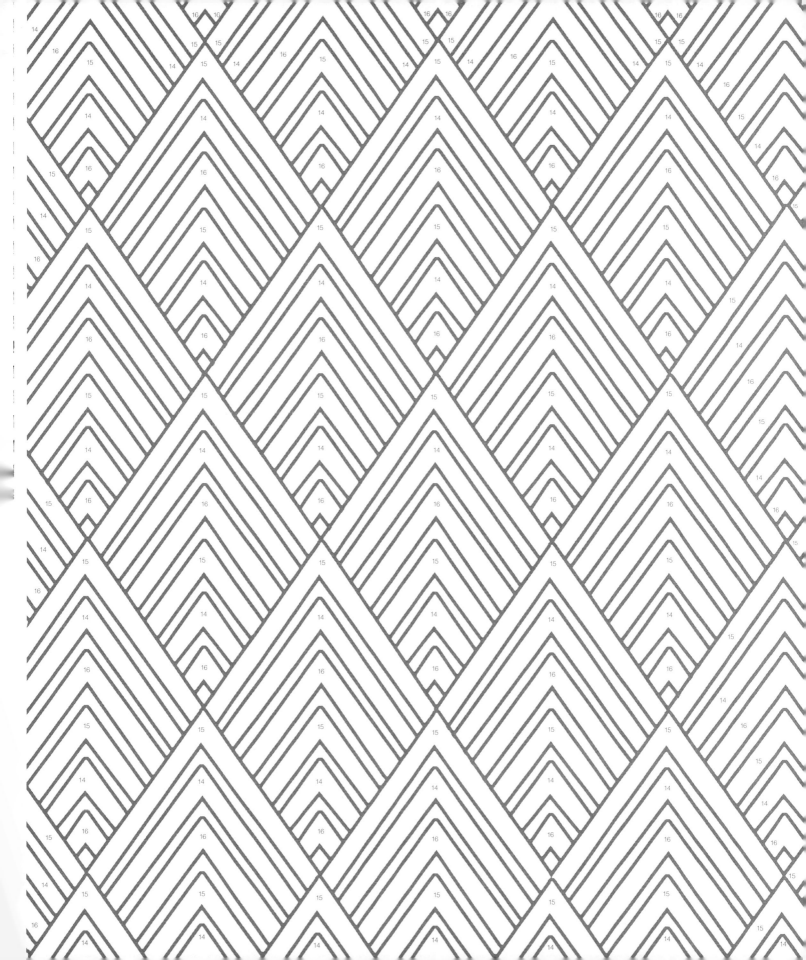

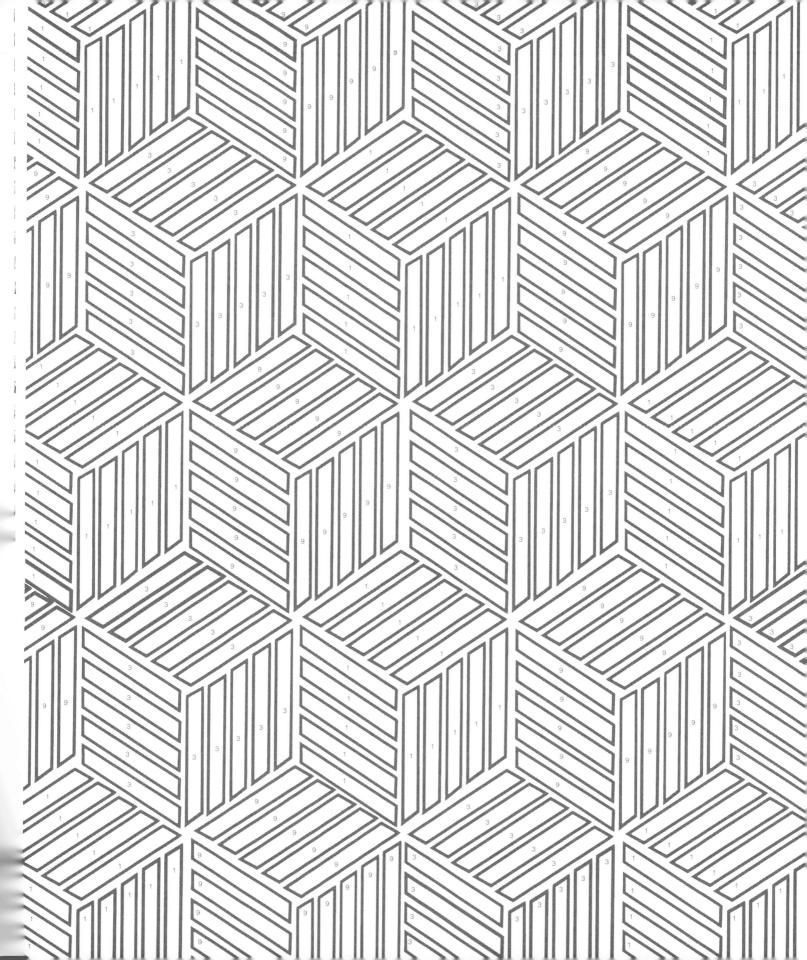

PATTERN 16

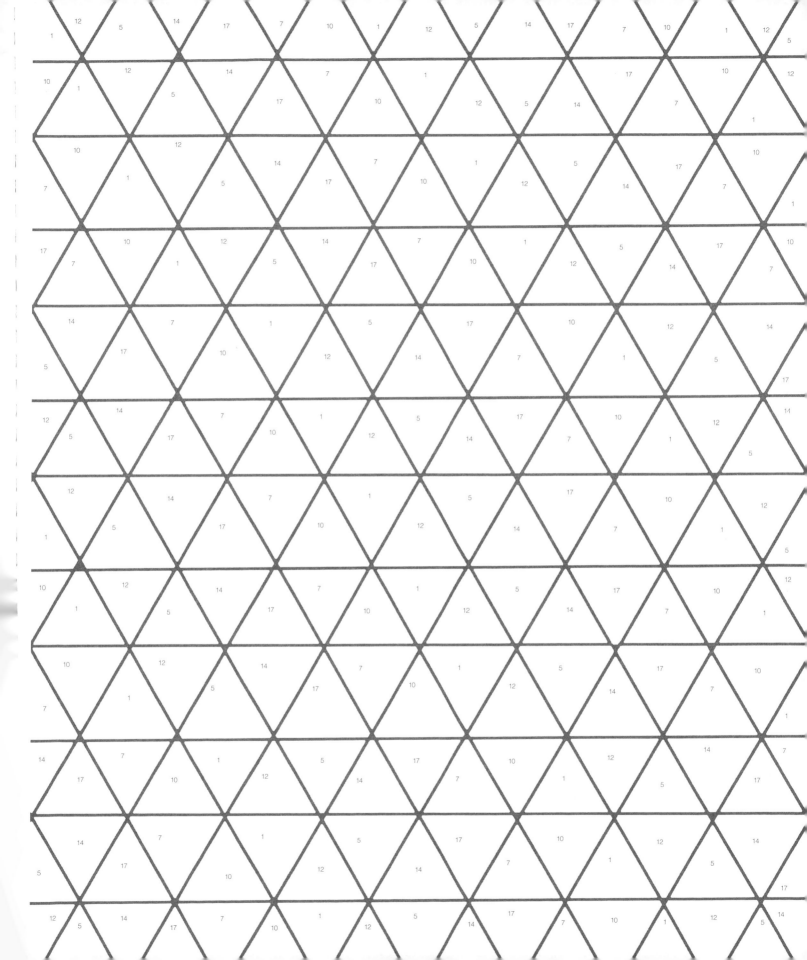

PATTERN 17

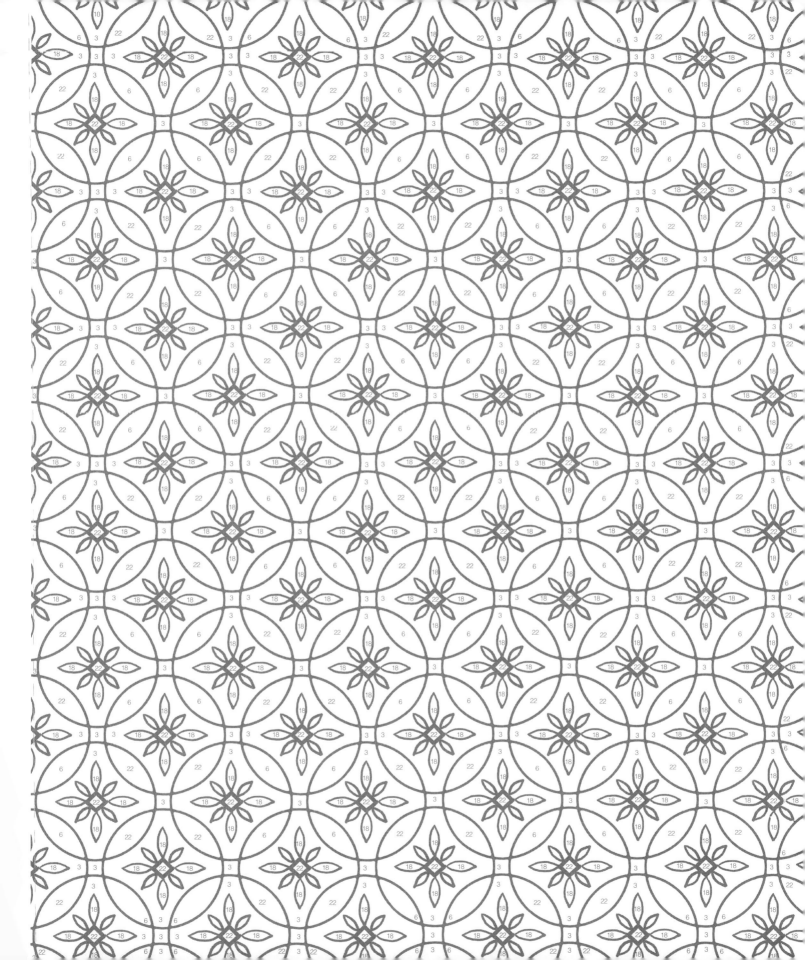

PATTERN 18

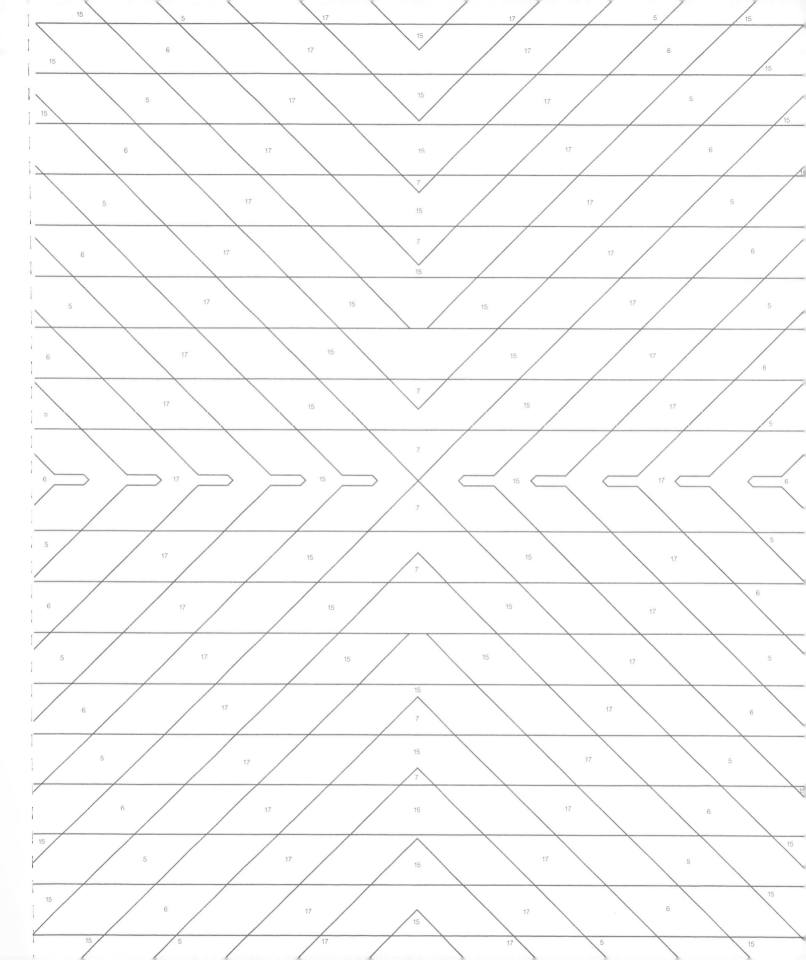

PATTERN 19

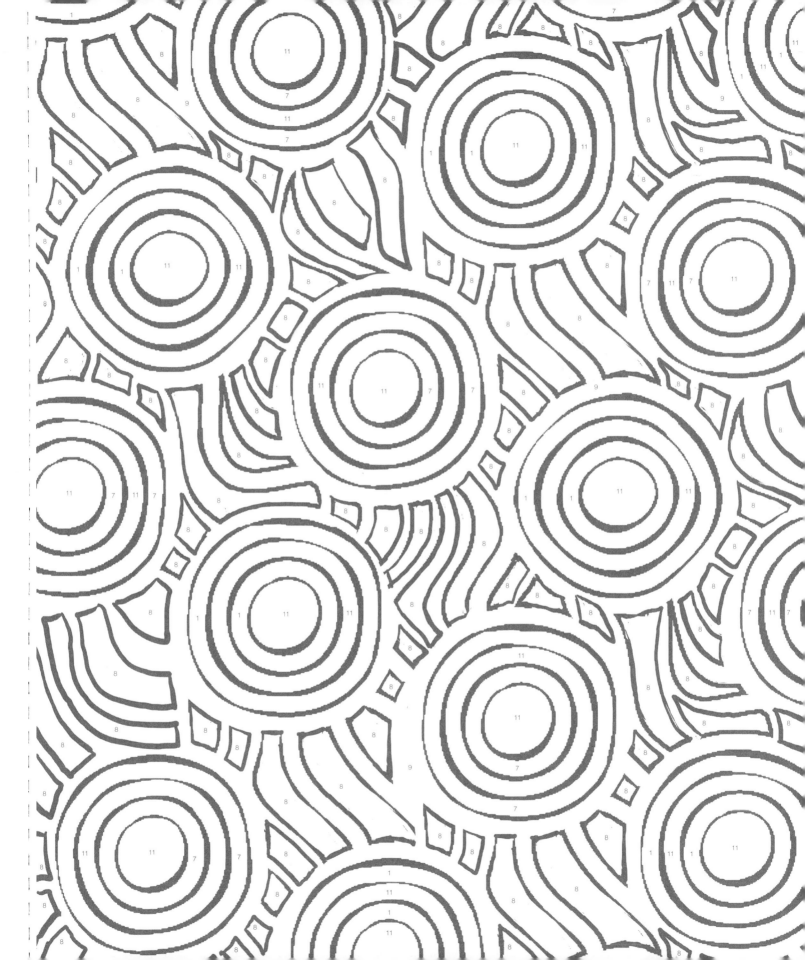

PATTERN 20

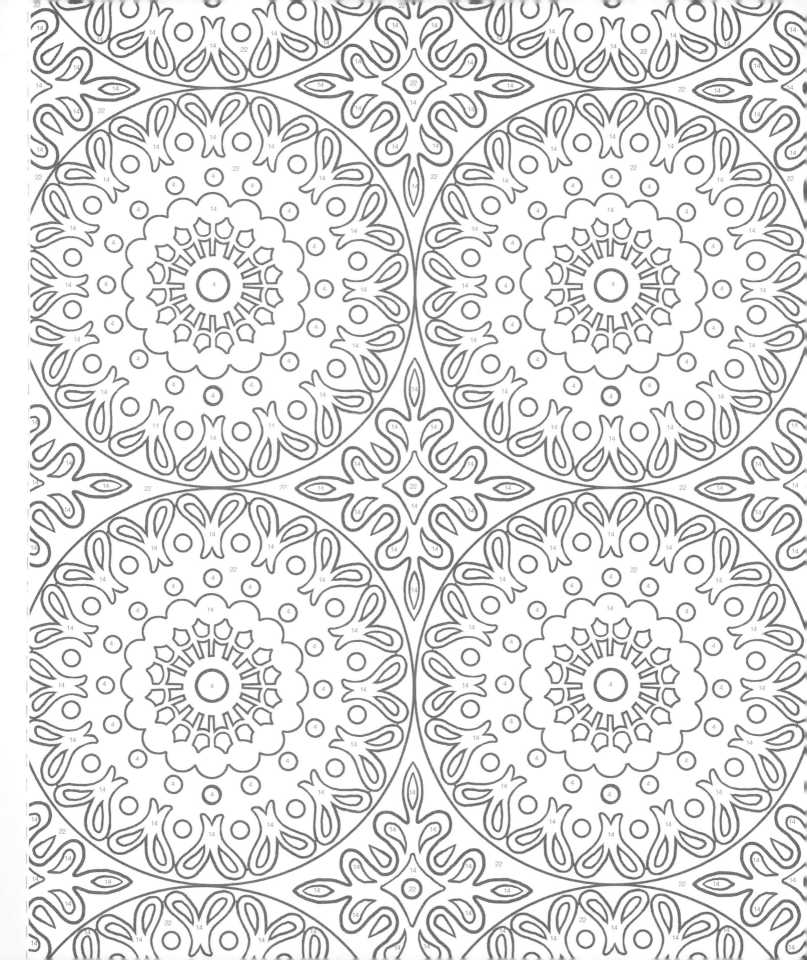

PATTERN 21

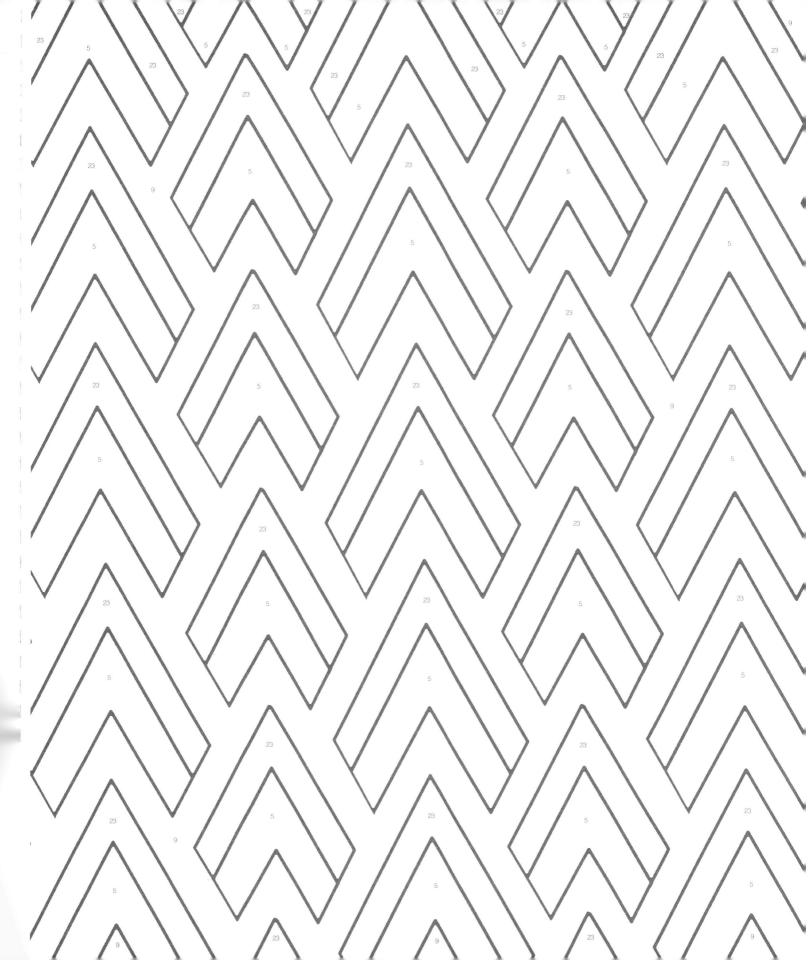

PATTERN 22

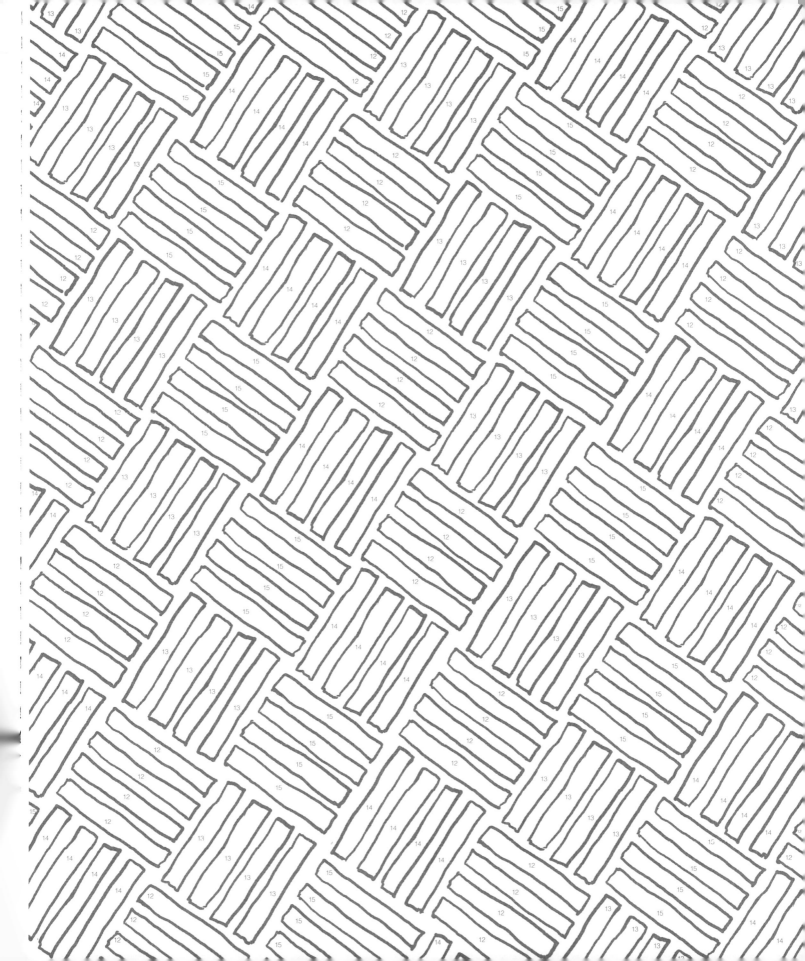

PATTERN 23

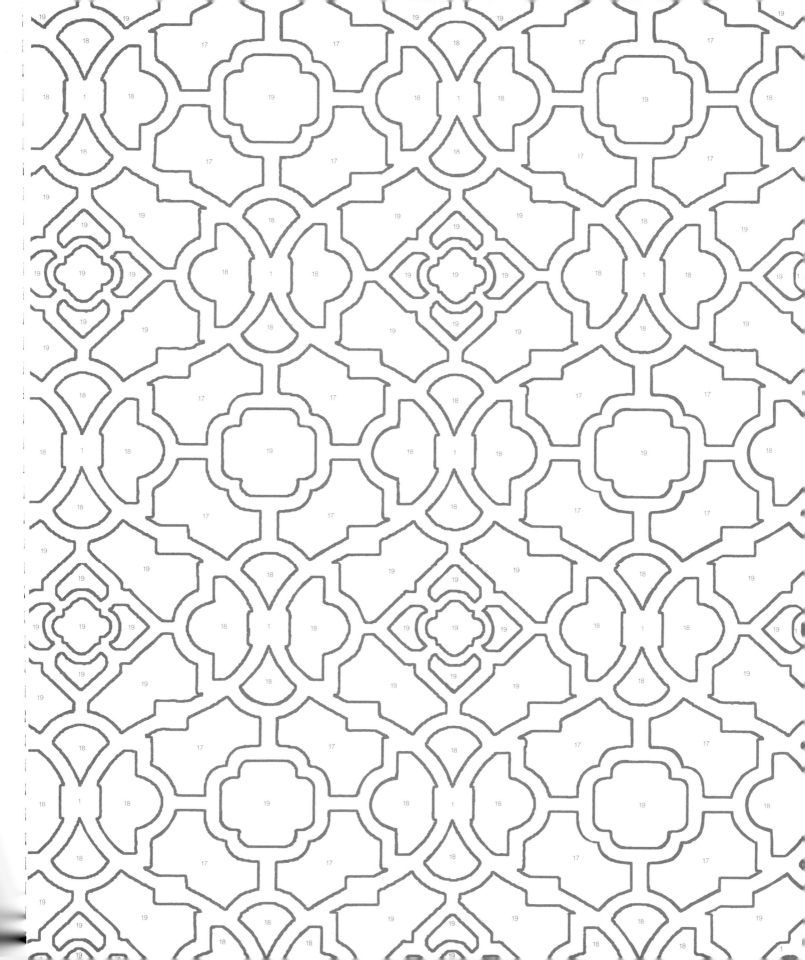

PATTERN 24

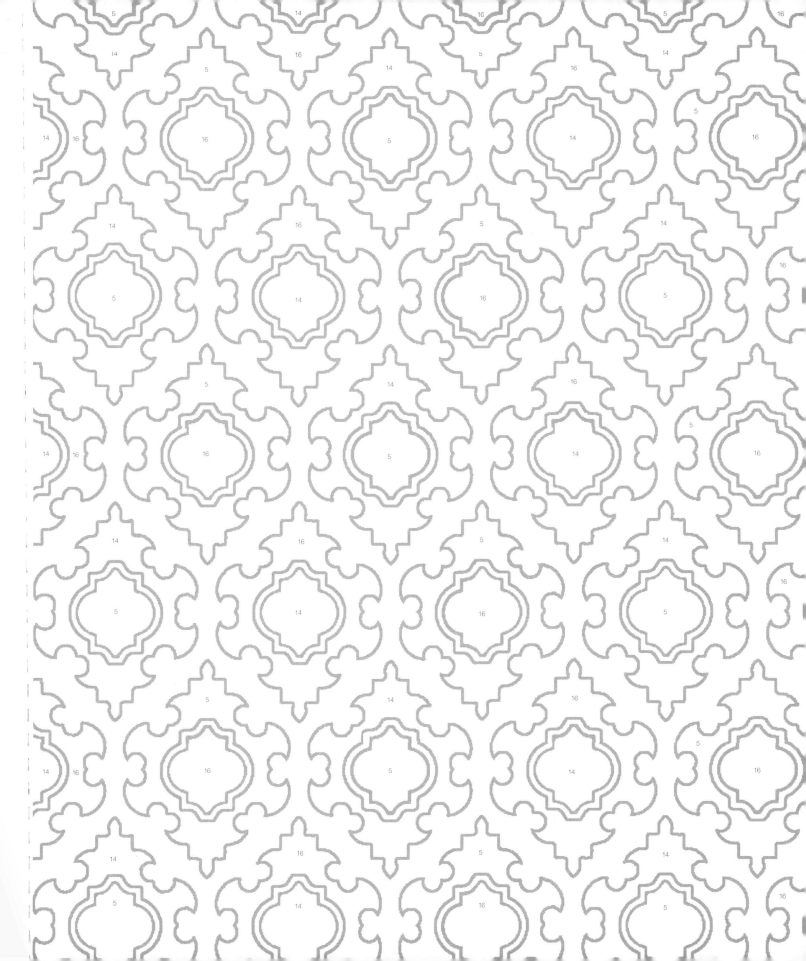

PATTERN 25

TEST PAGES